PHOTOGRAPHY AT THE MUSÉE D'ORSAY

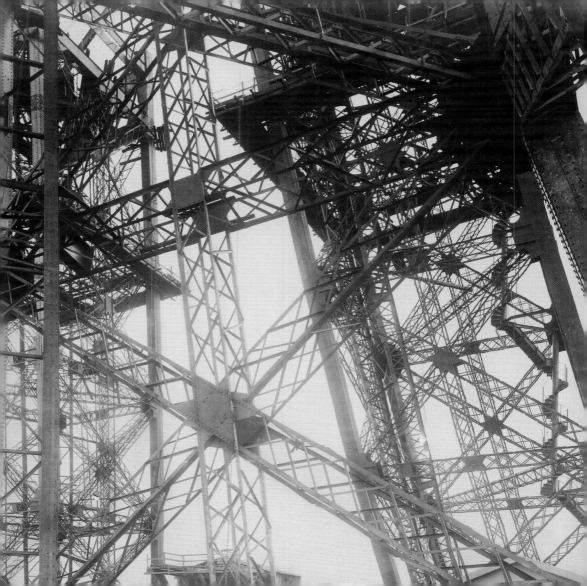

Joëlle Bolloch

The Eiffel Tower

CONTINENTS

This collection is directed by Serge Lemoine,
Chairman of the Musée d'Orsay.
All works reproduced in this volume belong
to the Musée d'Orsay's collection and
are kept in the museum.

The author would especially like to thank Elvire Deforge,
Dominique de Font-Réaulx, Isabelle Gaëtan,
Fabrice Golec, Françoise Heilbrun, Pierre-Yves Laborde,
Dominique Lobstein, Laure de Margerie, Caroline Mathieu
and Anne Pingeot for their precious help.

For Romane, Juliette, Peyo, Iban, Max and Basile.

Photographic credits and related rights are subject
to our knowledge of heirs and assigns. We apologise
to any who may have been omitted and ask them
to make themselves known to us.

All rights reserved. No part of this publication
may be reproduced, stored in a retrieval system,
or transmitted in any form or by any means.

www.musee-orsay.fr
info@5continentseditions.com

© Musée d'Orsay, Paris, 2005
© 5 Continents Editions srl, Milan, 2005

ISBN Musée d'Orsay : 2-905724-31-5
ISBN 5 Continents Éditions : 88-7439-260-5

Cover
Henri Rivière
*Trois ouvriers sur l'échafaudage d'une poutre
en arc du « Campanile »*
1889

For the Musée d'Orsay

Publication manager
Annie Dufour

Assisted by
Alice Ertaud

Iconography and digitalization
Patrice Schmidt

For 5 Continents Editions

Translation
Isabel Ollivier

Editorial Coordinator
Laura Maggioni

Design
Lara Gariboldi

Layout
Virginia Maccagno

Editing
Timothy Stroud

Colour Separation
Eurofotolit, Cernusco sul Naviglio (Milan)

Printed in October 2005
by Grafiche Milani, Segrate (Milan), Italy

Printed in Italy

Table of Contents

Joëlle Bolloch

The Eiffel Tower

"And so photography, which otherwise renders precious services, keeps trying to replace art by science and sentiment by exactness; and so iron, which is preferable to wood in almost all parts of construction, encroaches on architecture, changes its characteristic forms and ends up substituting industry for art."

Charles Garnier, "L'architecture de fer", *Le Musée des sciences*, 11 February 1857

An Alliance of Two Outcasts

In this diatribe of 1857, the architect Charles Garnier paired two of the great inventions that were to change the face of art in the second half of the nineteenth century: photography and the use of metal in architecture. Not that he contested their usefulness. He conceded that photography could render services, presaging Baudelaire's remark in his criticism of the 1859 Salon to which photography, previously exhibited alongside the products of industry, was admitted for the first time: "It must return to its true duty, which is to be the servant of the sciences and the arts, but a very humble servant, like printing and stenography, which neither created nor supplanted literature. Let it quickly enrich a traveller's album and give his eyes the precision that his memory seems to lack; let it adorn the naturalist's library, exaggerate microscopic animals, even fortify the astronomer's knowledge with a few facts; let it be the secretary and notebook for anyone whose occupation demands absolute material exactness, thus far nothing could be better." As for the use of iron in architecture, it is neither useless nor reproachable, as long as it is restricted to the attics and floors of traditional buildings, or to railway stations, hangars, market places, and hothouses…" because Garnier believed that "iron is a means, it will never be a principle".

These viewpoints reflect an opinion widely held in artistic circles which aimed to restrict the scope of metal architecture and photography, then both fledgling disciplines. Without denying the ideological and aesthetic aspects of the debate, it is important not to overlook the rivalry between architects and painters, on the one side, who wished to safeguard their respective fields, and engineers and photographers, on the other, seen as potential rivals.

These divisions persisted for several decades. By their very nature, engineering works such as bridges and railway lines, increasingly built of metal, were located outside of built-up areas. This fact was compounded by the political wish to relegate industry to the outskirts of the capital which meant that most of the buildings with a metal frame were erected in the suburbs. Wanting to publicise their achievements—since few people went to see them—the engineers used photography which was a faster and better means than painting to present their daring designs and the monumental nature of their buildings. Thus, restrictions on the use of iron and on the field of photography brought the two outcasts together. On one side of the divide stood Paris, stone architecture and painting; on the other, the suburbs, metal architecture and photography. This dichotomy came to an end, not without a last outburst of violent polemic, with the construction of the Eiffel Tower, in the heart of Paris, for the World's Fair 1889. It then became glaringly obvious that photography was the best means of representing metal architecture.

Objective: a Thousand Feet

The World's Fair, 1867, the first held on the Champ de Mars, had marked the height of the Second Empire; following defeat in war with Germany in 1870, the 1878 Fair

allowed France to take its place once more in the concert of great nations. Republican France in the early 1880s was in the midst of an economic crisis and chronic political instability. Determined to proclaim its principles all the same, it felt honour-bound to celebrate the first centenary of the French Revolution with special solemnity and to proclaim all its founding values. The organisation of a new World's Fair for 1889 seemed both a way to boost the economy, through major building projects, and an opportunity to recreate a political consensus around the centennial celebrations.

The project was mooted as early as 1880. At the same time, the idea of designing a monument to mark the fair in a spectacular way was born.

For some decades already the race for height had fired the public imagination; many engineers dreamed of exceeding the symbolic bar of 1,000 feet (about 300 metres). Several projects came to nothing: the 1,000-foot open-work cast iron column designed by the English engineer Trevithick, who died before construction began; nor the iron cylinder of the same height, dreamed up by the American engineers Clarke and Reeves for the 1876 World's Fair at Philadelphia, which failed to find funding.

In France, in 1883, Jules Bourdais, one of the architects of the Trocadero Palace, working with the engineer Amédée Sébillot, planned to endow Paris with a gigantic masonry and granite lighthouse of five storeys surrounded by galleries and topped with a metal lantern. Émile Nouguier and Maurice Koechlin, chief engineers with the Eiffel firm, sketched a "large pylon made up of four latticework beams spread at the base and meeting at the top, held together by metal beams at regular intervals". This preliminary project was submitted to Gustave Eiffel who authorised his engineers, without much enthusiasm, to go on with the project. After some changes made by Stephen Sauvestre, the architect attached to the Eiffel firm, the drawing was chosen for display at the Decorative Arts Exhibition to be held in autumn 1884 at the Palais

de l'Industrie. That was when Gustave Eiffel changed his mind and filed a patent in the names of Eiffel, Nouguier and Koechlin.

From then on Eiffel threw himself wholeheartedly into improving the project for a "300-metre iron tower for the 1889 exhibition" according to the title of the lecture he gave to the Society of Civil Engineers on 30 March 1885. He added technical details to increase the project's credibility, its cost, estimated at 3,155,000 francs, in fact, increased by a factor of 2.5; its weight, planned to be 6,500 tonnes, finally totalled 7,300; and construction time, estimated at one year, in fact required twenty-six months. He still hesitated between iron and steel, but eliminated masonry which he did not believe to be feasible. This judgement was intended to discredit Jules Bourdais, whom he esteemed his most dangerous rival.

Things began to take shape in May 1886. The budget for the Exhibition was voted and the programme drawn up more clearly. Édouard Lockroy, the Minister of Trade, who believed in Eiffel's project, could not openly refuse the project put forward by Bourdais, who was a friend of the chairman of the Council, Freycinet, and well placed in architectural circles. So he decided to hold a competition, the rules of which stipulated that: "Entrants must study the possibility of raising on the Champ the Mars an iron tower with a square base, measuring 125 metres on each side and 300 metres high". Chaired by Adolphe Alphand, the director of works for the city of Paris, the panel received 107 projects, including one by Bourdais who had switched from granite to iron, and, on 12 June, unanimously chose Gustave Eiffel's project. Meanwhile, Eiffel had bought sole ownership of the patent from Nouguier and Koechlin, agreeing to quote their names and pay each of them 1% of the sums he received. It then became pressing to make a decision about the site for the tower. Locations some distance from the Exhibition were quickly rejected. A choice had to

be made between those who wanted to put it on an elevated site, on Chaillot Hill, those who imagined a monument spanning the Seine, and supporters of the Champ de Mars, who finally won the day. An agreement was signed on 8 January 1887 between Édouard Lockroy, representing the French State, Eugène Poubelle, prefect of the Seine, on behalf of Paris, and Gustave Eiffel, on his own account. Eiffel undertook to build the tower and bring it into operation for the opening day of the Exhibition. He was to be granted a subsidy of 1,500,000 francs and authorisation to operate the tower throughout the Exhibition.

At the end of the Exhibition, the State would pass ownership of the monument to the city of Paris; Eiffel would keep the concession for twenty-one years after which the town council would take it over.

Construction, Photographers and Critics

"With a spurt of legitimate satisfaction, on 28 January 1887, I saw an army of earth-movers start work on the great excavations which will hold the base of the four feet of this tower which had been a constant preoccupation for me for over two years."

Several photographers frequented the construction site from the beginning, part of the tradition of photographers of engineering works which goes back to the 1850s, the most famous of whom in France was Édouard Baldus (1813–89). He was responsible for covering the construction of the new Louvre from 1854 to 1857, and the railway lines from Paris to Boulogne and Marseille.

Louis Émile Durandelle (1839–1917), who worked in partnership with Hyacinthe Delmaet until the latter's death in 1862, continued with Delmaet's widow, Clémence,

who soon became his wife. Under the company name of 'Delmaet and Durandelle' he had photographed the construction of the Paris Opera House by Charles Garnier. From the beginning of 1887 he set to work and made a series of painstakingly dated plates, long views, which show how quickly the tower went up from the foundations to the finishing touches in March 1889. Pierre Petit (1832–1909), better known for his portraits, was one of the photographers authorised to print the works presented at the World's Fairs in Paris in 1855, 1867 and 1878. He had also covered construction of the Statue of Liberty by Bartholdi, showing the structure designed by Gustave Eiffel, the stamping of the copper sheets, and the statue's temporary assembly in the rue de Chazelles, Paris, before it was dismantled and sent to New York. He was one of the first professional photographers on the site, even before construction began on the vacant lot of the Champ de Mars (cat. 1). Less well known, Théophile Féau (1839–92), a keen amateur and the inventor of a mechanical shutter, was given official permission to set up a tripod at the top of one of the towers of the Trocadero Palace. From there, without changing his viewpoint, he took a regular series of shots showing the construction of the Tower. He printed some in a leaflet rather like a short film on the construction (cats. 22–27).

The first problem facing Eiffel was that of the foundations. The subsoil on the chosen site, the part of the Champ de Mars that belonged to the city of Paris, enabled the concrete for the rear piles to be poured in the open air. But, for the two piles closer to the Seine, moisture and shifting sandy ground required the use of watertight metal cages and an injection of compressed air so work could be carried out below water level (cat. 5). While Gustave Eiffel was working on suitable solutions, opponents of the project kept up their attacks. As soon as the results of the competition were announced, the columns of trade magazines were opened to its

detractors. On 26 June 1886, P. Planat's column 'Causerie' in *La Construction moderne* headlined "La Tour-drague" and started: "The Eiffel Tower is my subject today. I have just been to see it, not out of pleasure, but by necessity, since its cumbersome person is forever in the public eye: impossible to open a political, literary or technical journal without coming across a pompous advertisement, with skeleton-sketches, in favour of this semaphore which is supposed to be the 'main attraction' of the future exhibition. Lord, what will the lesser attractions be?" On 14 February 1887, *Le Temps* published a petition addressed to Mr Alphand by a group of artists including Charles Garnier, Guy de Maupassant, Alexandre Dumas fils, François Coppée, Leconte de Lisle, Victorien Sardou, Sully Prudhomme, Charles Gounod, William Bouguereau and Ernest Meissonier. Probably written at the prompting of the architects of the Institute, who were furious to see public commissions escape them, this petition protested in the name of "little known French taste" against the erection in the centre of the capital of "the useless, monstrous Eiffel Tower" which will deface and dishonour the city. "To understand what we mean, just imagine a vertiginously ridiculous tower dominating Paris, like a huge black factory chimney, its barbarous mass crushing Notre Dame, the Sainte Chapelle, the Saint Jacques tower, the Louvre, the dome of the Invalides, the Arc de Triomphe, all our monuments will be humbled, all our architecture dwarfed and will disappear in this stupefying dream. And for twenty years we will see spread like an ink blot, throughout the whole city, still trembling from the genius of so many centuries, the odious shadow of the odious column of bolted iron. It is up to you who so love Paris, who have so beautified it, who have so often protected it from administrative destruction and the vandalism of industrial companies, to defend it once more."

Édouard Lockroy ironically suggested that Alphand should post the protest in the

windows of the Exhibition: "Such fine and noble prose signed by names known throughout the world could not fail to attract the crowds and even perhaps astonish them".

Gustave Eiffel defended himself in an interview published in *Le Temps* on the same day as the petition: "I believe that the Tower will have its own beauty. Because we are engineers, do people think that we do not care about the beauty of our constructions and that as well as making them strong and durable we do not try to make them elegant? [...] The Tower will be the highest building men have ever raised. Will it not therefore be grandiose in its way? And why should what is admirable in Egypt become hideous and ridiculous in Paris? I have thought about it and I admit I do not understand.

The protest says that the Tower will crush with its barbarous mass Notre Dame, the Sainte Chapelle, the Saint Jacques tower, the Louvre, the dome of the Invalides, the Arc de Triomphe, all our monuments. So many things at once! Really, what a joke! When you want to see Notre Dame, you go and stand on the square in front of it. How could the tower, on the Champ de Mars, bother someone standing on the square in front of Notre Dame, where he cannot even see it? Besides, it is one of the most mistaken notions, although widely held, even by artists, that a tall edifice will crush the surrounding buildings."

A Gigantic Meccano

On 1 July 1887 assembly work began. Once the massive masonry foundations were finished (cats. 2–4), the hardest part was building the diagonal pillars (cats. 6–9) and assembling them with the horizontal beams on the first level. The lower parts of the

piles were raised with gins fitted with hoisting gear. The gins (cat. 7) were made up of long pieces of wood tied together at the top, in the shape of an A. The principle was simple: a winch at the bottom, and a pulley at the top to roll the chain attached to the winch holding the piece to be lifted. Eiffel had foreseen everything, two of the piles were mounted on a hydraulic jack, so their incline could be adjusted at the last moment. He also put sand boxes between the horizontal beams and the scaffolding which supported them; by gradually emptying the sand the position of diagonal and horizontal pieces could be finely adjusted. The parts were lifted to a height of thirty metres without scaffolding by means of twelve-ton pivoting cranes using the runners later to be used for the lifts and going higher as the pillars rose. Then twelve temporary wooden scaffolds shored up the pillars, then others 45 metres high were needed to hold up the 70-tonne girders on the first platform. On 7 December (cat. 12) when the pieces were successfully assembled, Eiffel knew that he had won his bet.

After that construction was easier. The scaffolding was replaced by small wooden platforms around each edge. The first platform (cat. 13), 57 metres above the ground, then the second platform (cat. 17), at 115 metres, were successively used to haul materials up to the construction site. Past the second floor, nothing more was needed than the two cranes which used the runners of the future lifts.

Durandelle's almost exclusive interest in forms in his photographs mean few people were portrayed, but also reflects the way Eiffel organised the site. Much of the work was done in the company's workshops at Levallois-Perret. The pieces were designed and cut out in the workshops and arrived on the site partially assembled. If defects were detected, they were sent back to the factory but were never repaired on site. The 18,000 pieces making up the Tower required 700 drawings and 3,500 working drawings, which kept forty draughtsmen and calculators busy for two years. The workers

in the factory where two-thirds of the 2.5 million rivets were fitted numbered 150. On site, the main task was assembling the pieces like a gigantic Meccano set. The men worked in teams of four: the first heated a rivet in a small forge, the second inserted it in the hole and held it in place while the third hammered the other side and finally the fourth flattened the head with a sledgehammer.

In September 1888, the tower rose beyond the second platform. Considering that the work was getting more and more dangerous and annoyed to see their income drop because of shorter work hours in winter—twelve hours a day in summer, only nine in winter—the workers demanded a raise. After a two-day strike an agreement was reached. Tension rose again in December, but Eiffel threatened to consider that workers who did not go back on the job had resigned. He was deaf to the claim that the risk rose with the height of the site and indeed there was only one fatal accident in twenty-six months.

On average there were 200 workers rising to 250 at peak times, and they can be seen on photographs (cats. 30, 31, 35) taken by Henri Rivière (1864–1951). Better known for his engravings and drawings, Rivière was a practising photographer from the mid-1880s until probably just before World War I. His photographs of the Tower, taken just before completion, are much smaller than those of Durandelle or Petit. He took snapshots, close-ups and high and low-angle shots (cats. 28, 29, 36, 37). Rivière did not use the instant camera with flexible film marketed by Kodak in 1888, but a wooden camera with bellows, a frame and plates, which was nevertheless light and portable. In his viewfinder, the workers became acrobats (cat. 33), agile mountaineers, who turn to pose for the camera. Rivière worked at the Chat Noir theatre, and photographed members of the troupe who came to visit the Tower a few days before its completion (cat. 32). But, as much as the men working

on it, his eye was caught by the beauty of the monument itself, its architecture, and the spatial and visual surprises it had in store. When some thirty of Rivière's photographs were given to the Musée d'Orsay in the Eiffel papers in 1981, they were not immediately attributed to him though it was clear that the engraver had seen them before embarking on *Trente-six vues de la Tour*, a work with a Japanese flavour that pays tribute to Hokusai's *Thirty-six Views of Mount Fuji*. It was only five years later, when Rivière's heirs gave the museum about fifty new photographs known to be by him, several of which were identical to those already in the Eiffel collection, that they were attributed to Rivière.

Popular Acclaim for the Tower at the 1889 Exhibition

The Tower was completed on 31 March 1889. Surrounded by a few brave people who had climbed up with him, Eiffel ceremonially hoisted the flag on the top of the lightning conductor. The other guests waited lower down. And for good reason: the lifts were not yet in operation and did not begin to run until a week after the opening of the Exhibition on 15 May, so they had to climb the steps to the third platform (cat. 34)! To reach the first platform it was necessary to climb 387 steps, 674 to the second, 1,130 to the third and, finishing with a ladder, 1,710 to the summit. It took about thirty minutes to climb up to the third platform. A twenty-one gun salute was fired when the flag appeared.

"When the gates opened, when the crowd could at last touch the monster, stare at it all around, walk between its piers and climb on its flanks, the last resistance fell even among the most recalcitrant", wrote Eugène Melchior de Vogüé, adding: "perhaps,

rather than crushing the Exhibition, as people predicted, the triumphal gate would frame all its prospects without hiding anything". The photos taken by the Neurdein brothers and widely circulated confirmed this appreciation. Famous for the boost they gave postcards and for obtaining the right to use the photograph collection of the Historical Monuments Department between 1898 and the outbreak of World War I, Étienne (1832–after 1916) and Louis Antonin (1846–after 1916) Neurdein had recorded the construction of the Tower (cats. 18, 19, 20). But they continued their work bringing the monument to life by showing it in its environment during the World's Fair (cats. 38, 39). Under the brands "ND Phot" and "X Phot", they published souvenir albums that remained popular well into the first decades of the twentieth century. Their photographs show visitors on the walkways (cat. 43) and crowding into the lifts (cat. 44); the Tower is shown alongside its successive short-lived neighbours, the Machine Gallery (cat. 19), also built for the World's Fair (1889), the Trocadero Palace (cat. 39) and the sculptures that decorated the esplanade until 1937 (cat. 18). A later photograph, by an unknown photographer, shows the Tower with the smaller version of the Statue of Liberty, then on the Pont Grenelle (cat. 52), while another, dated 1948, depicts an incongruous visitor—an elephant no less— that seems to be wondering what it was doing there (cat. 53).

During the first week of the 1889 exhibition, before the lifts were in operation, 28,922 visitors climbed up to the first or second platforms. In 173 days, over 1,900,000 people visited the monument, an average of over 12,000 a day!

A theatre, a French restaurant and a Russian restaurant, a Flemish bistro and an English-American bar were installed on the first stage. The second had a printing press which brought out a special edition of *Le Figaro* each day, alongside shops and drink stalls. At the very top, two crisscrossed arches held the lantern from a

lighthouse and a three-branched lightning conductor stood on the narrow platform that crowned the summit at exactly 300 metres altitude.

Gustave Eiffel installed his office on the top platform and planned three laboratories respectively for astronomy, physiology and meteorology (cat. 45). Indeed, from the very outset, Eiffel had constantly said: "Apart from these spectacles that improve the mind, the Tower will have varied applications, either for national defence or in the scientific field". His deep interest in scientific research was compounded by the engineer's dream of making his monument indispensable to spare it demolition when the twenty-one-year concession expired. Many experiments were carried out. He was particularly concerned by the effects of wind on the structure, which were still poorly understood; he tended to overestimate them since he thought that the top of the tower would sway 70 centimetres whereas it in fact it has never exceeded 15. But Eiffel was haunted by the accident at Tarbes in 1884, when the viaduct he was building was blown into the valley during a storm. As a result he had an apparatus installed in 1903 between the ground and the second platform of the Tower (cats. 46, 47) to investigate air resistance on falling bodies. But it was its role in the development of the wireless that gave the Tower decisive strategic value and saved it from demolition. In 1910, the concession was renewed for seventy years.

A Symbol of Paris and Modernity

"The Tower is a symbol of Paris but it could be said that it won that place in opposition to Paris itself, its old stonework and its dense history; it has subdued the cities old symbols, just as physically it dominated their domes and spires. In short, it became

the symbol of Paris only when it raised the mortgage of the past and thus became the symbol of modernity. Its very aggression on the Paris landscape (underlined by the artists' petition) became welcoming; the Tower, with Paris itself, has made itself the symbol of creative daring, it was the modern gesture through which the present said no to the past", wrote Roland Barthes in *La Tour Eiffel,* published in 1964.

Once the monument was completed, several of the people who had signed the 1887 petition made amends, such as Sully Prudhomme who admitted he had "judged and condemned only by default". Painters (Georges Seurat, Henri Rousseau, Robert Delaunay and Marc Chagall, to name but a few), engravers, poets, and film-makers adopted the Tower, represented, cited and drew it and made their characters climb it. René Clair twice yielded to its charms, first as a setting for *Paris qui dort,* a fiction film made in 1923 (cats. 54, 55) and then with a documentary soberly entitled *La Tour* in 1928 (cats. 56–58).

A few years earlier, Gabriel Loppé (1825–1913), a former pupil of the Swiss landscape artist François Diday, who turned to photography in the 1880s, used artificial lighting to produce urban views (cat. 48) which presaged those of the American photographer Alfred Stieglitz. From the balcony of his apartment in the Avenue du Trocadéro, the Eiffel Tower was an excellent subject (cats. 49, 50), whether lighted or revealed in a flash of lightning (cat. 51). When she was in Paris in the 1920s, the German photo-journalist Else Thalemann (1901–85) took photos of the Tower that are astoundingly modern in their framing. Although the structure of the monument can still be seen on some shots (cat. 59), others give an abstract view infused with great visual poetry (cats. 60, 61).

An engineering achievement par excellence, the Tower gave rise to astonishingly modern photographs. Although they were taken with a view to recording the construction

of the monument, Durandelle's photographs exceeded their original function and established a new form of photography in which the void, triangulation and lines making complex networks are the main axes (cats. 14, 15). By the effects of repetition, accumulation and series, they were forerunners of the experiments at the Bauhaus or of Futurism, and the more recent work of Bernd and Hilla Becher, German photographers born in the 1930s who systematically recorded industrial buildings—silos, water towers, furnaces—with the emphasis on inventory, anonymity and the play of the structures. Henri Rivière's photographs, though they have obvious formal links with those taken by the Russian constructivist artist Alexander Rodchenko (1891–1956), also call to mind the work of Lewis Hine (1874–1940), especially the American photographer's reportage on the construction of the Empire State Building in 1930.

Entries

All the photographs here reproduced are in the Musée d'Orsay. Except for nos. 32, 33, 48, 49, 50, 59, 60, 61 and 62 they are part of the Eiffel collection, which joined the Musée d'Orsay in 1981 through the generosity of Mrs Bernard Granet and her children and Miss Solange Granet.

Pierre Petit (Aups, 1832–Paris, 1909)
Albumen prints.

1. *Le Champ-de-Mars avant la construction de la tour Eiffel* [The Champ de Mars before construction of the Eiffel Tower], 1887. 28.5 x 39 cm.
PHO 1981 125 20

2. *Début des travaux de terrassement* [The Beginning of the Earthworks], 1887, 28.5 x 38.5 cm.
PHO 1981 125 21

3. *Ouvriers et visiteurs posant près des rails et portant les chariots de terrassement* [Labourers and visitors posing near the rails with trolleys], 1887. 27.5 x 37.5 cm.
PHO 1981 125 23

4. Anonymous, *Maçonnerie des fondations* [Masonry for the foundations], April 1887. Albumen print, 27 x 37 cm.
PHO 1981 125 30

Louis-Émile Durandelle (Verdun, 1839–Bois-Colombes, 1917)

5. *Caissons métalliques* [Metal caissons], 28 April 1887. Albumen print, 27.5 x 43.5 cm.
PHO 1981 125 6

"We saw them dig these foundations with the help of compressed air caissons in the deep clay where the first inhabitants of Grenelle once hunted reindeer and aurochs. Soon the four megalithic feet of the elephant were weighted on the ground; from these stone hooves, the truss frame soon soared into space, overturning all our ideas about the balance of a building", Eugène-Melchior de Vogüé, *Remarques sur l'exposition du Centenaire*, 1889.

6. *Les premiers éléments métalliques d'une pile* [The first metallic pieces of a pier], 1887. Albumen print, 33 x 45 cm.
PHO 1981 125 8

7. *Ouvriers au travail sur un des piliers de la tour Eiffel* [Labourers at work on one of the piers of the Eiffel Tower], 18 July 1887. Albumen print, 34.2 x 44.4 cm.
PHO 1981 118 22

8. *Gustave Eiffel et un autre homme devant la pile n. 4* [Gustave Eiffel and another man in front of the fourth pier], 18 July 1887. Albumen print, glued on card, 33.5 x 44 cm.
PHO 1981 125 9

9. *Les quatre piles, au second plan le palais du Trocadéro* [The four piers, the Trocadero Palace in the background], 30 August 1887. Albumen print, 26 x 45 cm.
PHO 1981 125 13

10. Anonymous, *Poutrelles métalliques devant deux piles en construction* [Metal girders in front of two piers under construction*, 1887. Albumen print, 27.5 x 37 cm.
PHO 1981 125 33

11. Anonymous, *Visite à la tour Eiffel en construction* [Visit to the Eiffel Tower under construction], 1887. Albumen print, 11.5 x 16.3 cm.
PHO 1981 108 68

Louis-Émile Durandelle
Albumen prints.

12. *Les piliers de la tour Eiffel* [The pillars of the Eiffel Tower], 7 December 1887. 28.9 x 44.6 cm.
PHO 1981 118 25

13. *Les quatre piliers de la tour Eiffel et le commencement de la 1re plate-forme* [The four pillars of the Eiffel Tower and the beginning of the first platform], 7 January 1888. 29.9 x 44.8 cm.
PHO 1981 118 26

14. *Ouvriers au travail sur les poutres métalliques* [Labourers working on the metal girders], 14 January 1888. 34.4 x 43.9 cm.
PHO 1981 118 27

15. *La 1re plate-forme* [The first platform], 16 June 1888. 44.4 x 34.2 cm.
PHO 1981 118 36
"I saw the Eiffel Tower grow. We used to go to see it after school, our jackets puffed up by our satchels. Our parents watched its progress, whistling as they did when they measured their son with a pencil mark on a wall. [...] with our hearts in our mouths, we made out a red halo of work above the first platform, a sort of sonorous fog, in which we sometimes saw the handle of a hammer rise like the flight of a crow which then flopped back in the dust", Léon-Paul Fargue, *Le Piéton de Paris*, 1932–39

16. *Cuisiniers* [Cooks], 4 July 1888. 34.4 x 44.3 cm.
PHO 1981 118 45

17. *La Tour au niveau de la 2e plate-forme, au second plan le palais du Trocadéro* [The tower at the second platform, with the Trocadero Palace in the background], 19 July 1888. 44.3 x 34.1 cm.
PHO 1981 118 46
Huysmans did not mince his words when describing M. Eiffel's tower which "looks like a factory chimney in construction, a carcass waiting to be filled by stone or bricks. It is impossible to imagine that this infundibuliform netting is finished, that this solitary suppository peppered with holes will stay here". But neither did he like the "platitude and pastiche" built by Gabriel Davioud and Jules Bourdais in "[...] this incoherent Trocadero Palace which, seen from a distance, with its enormous rotunda and frail minarets with gold bells looks like the belly of a hydropic woman lying with her head on the ground and waving in the air two thin legs clad in net stockings and gold mules [...]".

18. X Phot [Neurdein brothers], *Les travaux de la tour Eiffel* [Work on the Eiffel Tower], August 1888. Albumen print, 21 x 27 cm.
PHO 1981 133 1
Four animal sculptures decorated the fountains of the Trocadero Palace from the World's Fair in 1878 until that of 1937 when the building was replaced by the present Palais de Chaillot. The *Bull,* by Auguste Caïn, was sent to Nîmes, while the others were placed in gardens in Paris. The *Rhinoceros,* sculpted by Alfred Jacquemart, the *Horse with the Harrows,* by Pierre Rouillard, and the *Young Elephant in a Trap,* by Emmanuel Frémiet, are now on the esplanade in front of the Musée d'Orsay.

19. Neurdein brothers, Étienne (1832–after 1916) and Antonin (1846–after 1916), *La Tour en construction jusqu'à la 2ᵉ plate-forme* [The Tower under construction up to the second platform], 1888. Albumen print, 21 x 27 cm.
PHO 1981 133 2
The Pont d'Iena is guarded by four warriors. The Arab and Greek warriors, respectively by the sculptors Jean-Jacques Feuchère and François Devaulx, lord it at the left bank end of the bridge while Antoine-Auguste Préault's *Gallic Warrior* and Louis Daumas' *Roman Warrior* stand on the right bank. In 1937 the bridge was widened and the statues were swapped round and turned so they faced one another.

20. X Phot [Neurdein brothers], *Une pile* [A pier], September 1888. Albumen print, 27 x 21 cm.
PHO 1981 133 7

21. Neurdein brothers, *Les culées d'une pile* [The abutments of a pier], September 1888. Albumen print, 21.5 x 27.9 cm.
PHO 1981 125 59
In an essay in favour of "L'architecture et le fer", Raymond Duchamp-Villon deplored the disappearance of the Machine Gallery, demolished in 1910. "So we dared not or knew not how to defend against the forces of speculation a powerful, audacious work, trumpeting the glory of steel in a fantastic hangar: the Machine Gallery. Built for the 1889 Exhibition, the memory of it dominates our first impressions of community life, and I can still clearly see in the light of the immense vessel, the hallucinatory progress of the travelling crane above the whirling flywheels, the snake-like straps, among the creaking, whistles and sirens, and looming up from the black hole the discs, pyramids and cubes."

Théophile Féau (Orleans, 1839–Paris, 1892)
Albumen prints, each print 24.8 x 10.4 cm.

22. *La tour Eiffel en construction* [The Eiffel Tower under construction], June and July 1888.
PHO 1981 126 5 1 and PHO 1981 126 5 2

23. *La tour Eiffel en construction* [The Eiffel Tower under construction], 14 August and 14 September 1888.
PHO 1981 126 6 1 and PHO 1981 126 6 2

24. *La tour Eiffel en construction* [The Eiffel Tower under construction], 14 October and 14 November 1888.
PHO 1981 126 7 1 and PHO 1981 126 7 2

25. *La tour Eiffel en construction* [The Eiffel Tower under construction], 26 December 1888 and 20 January 1889.
PHO 1981 126 8 1 and PHO 1981 126 8 2

26. *La tour Eiffel en construction* [The Eiffel Tower under construction], 12 February and 12 March 1889.
PHO 1981 126 9 1 and PHO 1981 126 9 2

27. *La tour Eiffel en construction* [The Eiffel Tower under construction], 2 April 1889. 25.5 x 19.5 cm.
PHO 1981 126 10
"As the Tower climbed, added its platforms, and its girders rose still higher, cunningly linked to each other, we saw the masterpiece, whose uprights seemed first to leap haphazardly into space, settle down, take its relative proportions, shrink down in its force and power until it left before the eyes of the amazed spectator the structure of an immense

unknown cathedral at the bottom, and an unexpectedly daring and moving spire at the top", Max de Nansouty, *La Tour de 300 mètres érigée au Champ-de-Mars*, undated.

Henri Rivière (Paris, 1864–1951)
Silver prints, 12 x 9 cm.

28. *Échafaudage sur le Campanile, vue plongeante sur la Seine* [Scaffolding on the Campanile, plunging view of the Seine], 1889.
PHO 1981 124 10

29. *Visiteur sur un échafaudage du pilier nord, vue plongeante, à l'arrière-plan un drapeau, la Seine et la rive droite* [Visitor on scaffolding on the north pillar, plunging view, a flag, the Seine and the right bank in the background], 1889.
PHO 1981 124 3

30. *Ouvriers sur un échafaudage travaillant sur une partie verticale* [Workers on a scaffold working on an upright], 1889.
PHO 1981 124 11
Early in 1889, Émile Goudeau, a journalist who had founded the *Journal des hydropathes* and worked at the Chat Noir theatre, told of his visit to the construction site. "Over there they were still working on the bolts: workmen with their iron bludgeons, perched on a ledge just a few centimetres wide, took turns at striking the bolts [these in fact were the rivets]. One could have taken them for blacksmiths contentedly beating out a rhythm on an anvil in some village forge, except that these smiths were not striking up and down vertically, but horizontally, and as with each blow came a shower of sparks, these black figures, appearing larger than life

against the background of the open sky, looked as if they were reaping lightning bolts in the clouds."

31. *Un peintre sur une corde à nœuds le long d'une poutre verticale, au-dessus d'un assemblage de poutres* [A painter on a knotted rope along a vertical girder, above a set of girders], 1889.
PHO 1981 124 20

32. *Henri Jouard et Rodolphe Salis, sur la dernière plate-forme* [Henri Jouard and Rodolphe Salis, on the top platform], 1889 .
Gift from Mrs Guy-Loé and Miss Noufflard.
PHO 1986 122 23
Rodolphe Salis and Henri Jouard were respectively the founder and director of the Chat Noir theatre and its manager.

33. *Un ouvrier debout le long d'une poutre* [A worker standing on a girder], 1889.
Gift from Mrs Guy-Loé and Miss Noufflard.
PHO 1986 122 57

34. *Quatre visiteurs sur un escalier* [Four visitors on a staircase], 1889.
PHO 1981 124 6

35. *Quatre ouvriers posant sur un échafaudage au pied du «Campanile», à l'arrière-plan la Seine en amont de la Tour* [Four workers posing on a scaffold at the foot of the "Campanile"], 1889.
PHO 1981 124 5

36. *Trois ouvriers sur l'échafaudage d'une poutre en arc du «Campanile»* [Three workers on the scaffold of an arched girder on the "Campanile"], 1889.
PHO 1981 124 26

37. *Le «Campanile», la lanterne du phare et le paraton-nerre, vue en contre-plongée* [The "Campanile", the lantern of the lighthouse and the lightning conductor, seen from below], 1889.
PHO 1981 124 27

38. X Phot [Neurdein brothers], *Le parc du Champ-de-Mars et la tour Eiffel* [The park of the Champ de Mars and the Eiffel Tower], 1889.
Albumen print, 21 x 27 cm.
PHO 1981 133 17

ND Phot [Neurdein brothers]
Albumen prints, 21 x 27 cm.

39. *Au pied de la tour Eiffel* [At the foot of the Eiffel Tower], 1889.
PHO 1981 133 20

40. *La tour Eiffel, détail du « Campanile »* [Eiffel Tower, detail of the "Campanile"], 1889.
PHO 1981 133 22

41. Anonymous, *Eiffel, Salles, Milon et M^me Salles au sommet de la tour Eiffel* [Messrs. Eiffel, Salles, Milon and Mrs Salles at the top of the Eiffel Tower], 1889.
Albumen print from a glass negative, 27.8 x 21.6 cm.
PHO 1981 125 98

ND Phot [Neurdein brothers], album "Souvenir de la tour Eiffel".
Photomechanical prints, 9 x 14 cm.

42. *Le canon de la tour Eiffel au moment où il va annoncer l'heure de midi* [The cannon of the Eiffel Tower about to announce midday], 1900. Plate no. 9.
PHO 1981 132 10 9

43. *La tour Eiffel, galerie extérieure du 2^e étage* [The Eiffel Tower, outer gallery on the second level], 1900. Plate no. 10.
PHO 1981 132 10 10
In *Une visite à l'Exposition de 1889*, Henri Rousseau describes a provincial couple, Mr and Mrs Lebozeck, visiting Paris with their maid, Mariette, coming in sight of the Tower:
"MARIETTE, SEEING THE TOWER
– Ah, Holy Mother of God, how fine it is, how fine it is and what is that great ladder there, it is much higher than our church tower. Lordy, but its funny, but how do you get up, the rungs are not round and worse still they are all crooked. But look there are people climbing up all the same and they are all at the top and gracious me they are as big as bugs; so how did they get in. […]
LEBOZECK, SPOTTING THE CARETAKER
– Hey, my good fellow, I have something to ask you. Could you tell me how to go about climbing up to the top of this great ladder?
THE CARETAKER, RATHER RUFFLED
– Did you say this great ladder? May I tell you, Sir, it is the Eiffel Tower, the highest in the whole world, because remember that it is three hundred metres high. Where do you come from then? Have you never heard of it?

44. *Changement de cabine d'ascenseur pour les voya-geurs qui se rendent du 2^e au 3^e étage – à 200 mètres du sol* [Changing the lift cabin to take passengers from the second to the third platform – 200 metres from the ground], 1900. Plate no. 11.
PHO 1981 132 10 11

The height of the monument, the varying angles and slopes and the heavy loads required made installing lifts a particularly complicated operation. Each section was handled by a different company: the French company Roux, Combaluzier et Lepape designed the machine taking tourists to the first platform, the American company Otis that which served the second platform, and the lift from the second to the third platform, a distance of 160 metres, was made by Edoux. Edoux designed a double elevator with two cabins balancing one another, the inner cabin serving as a counterweight. Passengers had to change cabins halfway. The lift was closed from November to March because of the danger that the water reservoir used by the hydraulic piston might freeze. Nonetheless the lift designed by Edoux operated for 93 years, until 1982!

45. *Le Sommet de la tour Eiffel* [The top of the Eiffel Tower], 1900. Plate no. 15.
PHO 1981 132 10 15
Henri Manuel (1874–1947)

Henri Manuel (1874–1947)

46. *Gustave Eiffel et l'appareil de chute à la tour Eiffel* [Gustave Eiffel and the apparatus for experimenting with falling bodies under the Eiffel Tower], 1907. Silver print, 17 x 12 cm.
PHO 1981 135 1

47. *MM. Rith, Eiffel et Milon devant l'appareil de chute sous la tour Eiffel* [Messrs. Rith, Eiffel and Milon in front of the apparatus for experimenting with falling objects under the Eiffel Tower], 1907. Photomechanical print (heliogravure) glued on card, 23 x 17 cm.
PHO 1981 135 37

Gabriel Loppé (Montpellier, 1825 – Paris, 1913)
Aristotype prints (citrate prints)

48. *Quai de la Seine et la tour Eiffel, dans la nuit* [Quay of the Seine and the Eiffel Tower, at night], c. 1900 18 x 13 cm. Gift of the Société des amis du musée d'Orsay. PHO 1989 5 4

49. *La tour Eiffel et vue des toits* [The Eiffel Tower and view of the rooftops], c. 1900. 18 x 13 cm
Gift of the Société des amis du musée d'Orsay in 1989.
PHO 1989 5 5

50. *Illuminations de la tour Eiffel* [Illumination of the Eiffel Tower], c. 1900. 13 x 18 cm.
Gift of the Société des amis du musée d'Orsay.
PHO 1989 5 14
This print shows the Algerian pavilion and the Ferris Wheel which suggests that it was taken during the World's Fair.

51. *La tour Eiffel foudroyée* [The Eiffel Tower struck by lightning], 3 June 1902. 17.5 x 12.5 cm
PHO 1981 132 1
On 15 June 1905, Gabriel Loppé wrote to Gustave Eiffel: "Paris, 14 avenue du Trocadéro. I do not have any prints of the photograph of the tower struck by lightning, just at the moment. After losing a large number of negatives through the carelessness of the professionals to whom I gave them to make prints, I have decided to do all these tedious operations myself to have a few gifts to give my friends. So I am going to prepare some fixative to make the two prints that your correspondents have asked you to send them." Eiffel collection, ARO 1981 1307.

52. Photographic department of the New York Times, *La tour Eiffel avec la statue de la Liberté* [The Eiffel

Tower with the Statue of Liberty], undated. Silver print.
PHO 1981 134 12
A small bronze version of the Statue of Liberty was installed on the Pont Grenelle in 1889. The statue faced Paris at first but on the occasion of the World's Fair, 1937, was turned round at Bartholdi's request to face the sea and New York! When the present bridge was built the statue was moved to the downstream tip of the Ile aux Cygnes.

53. Anonymous, *Un éléphant du cirque Bouglione au 1ᵉʳ étage de la tour Eiffel* [An elephant from the Bouglione circus on the first platform of the Eiffel Tower], 4 July 1948. Silver print, 6 x 8.5 cm.
PHO 1981 134 1
The elephant was 85 years old and went no further than the first platform.

René Clair (Paris, 1898–1981)

54. *Photographie de plateau réalisée pendant le tournage du film «Paris qui dort»* [Photograph taken on the set of the film "Paris qui dort"], 1923. Silver print, 24 x 18 cm.
PHO 1981 131 18

55. *Photographie de plateau réalisée pendant le tournage du film «Paris qui dort»* [Photograph taken on the set of the film "Paris qui dort"], 1923. Silver print, 24 x 18 cm.
PHO 1981 131 21
In his first film, made in 1923, René Clair imagined that a scientist had used an invisible ray to put the capital to sleep. Only the caretaker of the Tower and the passengers of an aeroplane who had taken refuge on the third platform stayed awake… While the city slumbered, they could still see. The actors Albert Préjean, Madeleine Rodrigue, Marcel Vallée and Henri Rollan.

56. *La tour Eiffel, un pied vu en plongée* [One pier of the Eiffel Tower, seen from above], 1928. Silver print taken from the film *La Tour*, 18 x 24 cm.
PHO 1981 131 12

57. *La tour Eiffel, antennes de télégraphie* [The Eiffel Tower, telegraph antennas], 1928. Silver print from the film *La Tour*, 18 x 24 cm.
PHO 1981 131 8

58. *La tour Eiffel, gros plan sur une arête* [The Eiffel Tower, close up of an edge], 1928. Silver print from the film *La Tour*, 18 x 24 cm.
PHO 1981 131 2

Else Thalemann (Berlin, 1901 – Mölln, 1985)
Silver prints.

59. *La tour Eiffel, détail* [The Eiffel Tower, detail], c. 1925. 17.6 x 12.6 cm.
PHO 1986 43 6

60. *La tour Eiffel, détail* [The Eiffel Tower, detail], c. 1925 17.8 x 12.5 cm.
PHO 1986 43 1

61. *La tour Eiffel, détail* [The Eiffel Tower, detail], c. 1925 17.6 x 12.6 cm.
PHO 1986 43 2

62. *La tour Eiffel, vue d'ensemble avec quatre hommes de dos* [The Eiffel Tower, full view with four men seen from behind], c. 1925. 17.6 x 12.6 cm.
PHO 1986 43 3

Selected Bibliography

BARTHES, Roland. *La Tour Eiffel*. Paris: Delpire, 1964.

BAUDELAIRE, Charles. "Salon de 1859 : le public moderne et la photographie". In *Écrits sur l'art*. Paris: Librairie générale française, Livre de Poche, 1992 (*Œuvres complètes*, Éditions du Seuil, 1968, pp. 394–96).

DESJOURS, Jean, LEMOINE, Bertrand. *Le Grand Œuvre. Photographies des grands travaux, 1860-1900*. Paris: Photo Poche no. 11, 1983.

DUCHAMP-VILLON , Raymond. *L'Architecture et le Fer. La Tour Eiffel*. Paris: L'Échoppe, 1994.

EIFFEL, Gustave. *L'Architecture métallique*, preface by Xavier Larnaudie-Eiffel. Paris: Maisonneuve et Larose, 1996.

FARGUE, Léon-Paul. *Le Piéton de Paris*. Paris: Gallimard, 1932.

FOSSIER, François, HEILBRUN, Françoise, NÉAGU, Philippe. *Henri Rivière graveur et photographe*. Exh. cat., Musée d'Orsay / Bibliothèque nationale de France. Paris: Réunion des musées nationaux, collection "Les dossiers du musée d'Orsay", no. 23, 1988.

GRANET, Amélie. *Catalogue sommaire illustré du fonds Eiffel. Musée d'Orsay*. Paris: Réunion des musées nationaux, 1989.

HUYSMANS, Joris-Karl. *L' Art moderne – Certains*. Paris: Union générale d'édition, collection "10/18", 1975.

JENGER, Jean. *Souvenirs de la Tour Eiffel*. Paris: Réunion des musées nationaux, 1989.

LEMOINE, Bertrand. *La Tour de Monsieur Eiffel*. Paris: Gallimard, collection "Découvertes", 1989.

——, *Gustave Eiffel*. Paris: Fernand Hazan, 1984.

LOYRETTE, Henri. *Gustave Eiffel*. Paris: Payot, 1986.

——, "Ingénieurs et photographes". In *Photographies*, special issue "Photographie, art moderne et technologie", no. 5, July 1984.

MARREY , Bernard. *La Vie et l'Œuvre extraordinaires de Monsieur Gustave Eiffel, ingénieur qui construisit la Statue de la Liberté, le Viaduc de Garabit, l'Observatoire de Nice, la Gare de Budapest, les Écluses de Panama, la tour Eiffel, etc*. [Paris]: Graphite, 1984.

——, *Gustave Eiffel et son temps*. Exh. cat. Paris: Musée de la Poste, 1983.

MATHIEU, Caroline, LOYRETTE, Henri, CROSNIER-LECONTE, Marie-Laure, et al. *1889 La Tour Eiffel et l'Exposition universelle*. Exh. cat. Paris: Réunion des musées nationaux, 1989.

NANSOUTY, Max DE. *La Tour de 300 mètres érigée au Champ-de-Mars, Paris*, undated.

PEREGO, Elvire. "Delmaet et Durandelle, ou 'la rectitude des lignes'". In *Photographies*, special issue "Photographie, art moderne et technologie", no. 5, July 1984.

PINGEOT, Anne. *1878. La Première Exposition universelle de la République*. Paris: Réunion des musées nationaux, collection "Carnet-parcours du musée d'Orsay", no. 14, 1988.

ROUSSEAU, Henri, called Le Douanier. *Une visite à l'Exposition de 1889*. Vaudeville in 3 acts and 10 tableaux, in *Théâtre*. Paris: Christian Bourgois, republished 1984.

SESMAT, Pierre. *La Tour Eiffel a cent ans*, "Textes et documents pour la classe", no. 513. Paris: Centre national de documentation pédagogique, 22 March 1989.

VOGÜE, Eugène-Melchior de. *Remarques sur l'exposition du Centenaire*. Paris: Plon, 1889.

COLLECTIVE PUBLICATION, *Fer Lorrain – Tour Eiffel, 1889*. Exh. cat., Musée du Fer, Jarville, 1980.

COLLECTIVE PUBLICATION, *Gustave Eiffel*. Exh. cat. Dijon: Cellier de Clairvaux, 1981.

Films

CLAIR, René, *Paris qui dort*, 1923.

——, *La Tour, documentary*, 1928.

Magazines

La Construction moderne, between 1884 and 1889.

L'Illustration, between 1884 and 1889.

Website of the Eiffel Tower: http://www.tour-eiffel.fr

Plates

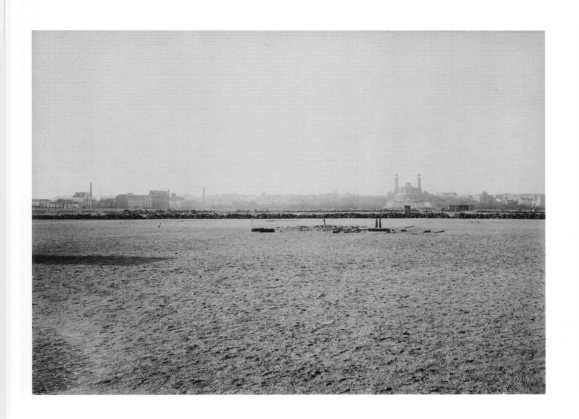

1. Pierre Petit
Le Champ-de-Mars avant
la construction de la tour Eiffel
1887

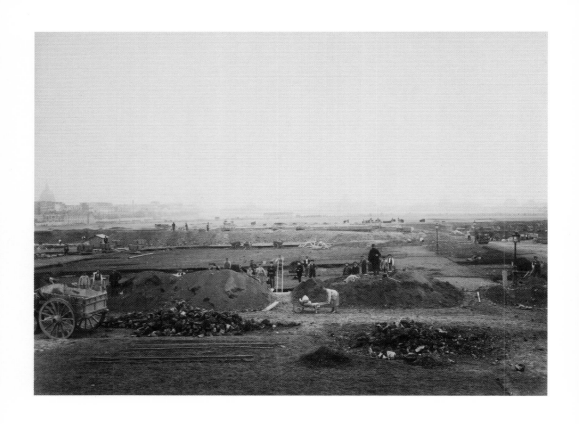

2. Pierre Petit
*Début des travaux
de terrassement*
1887

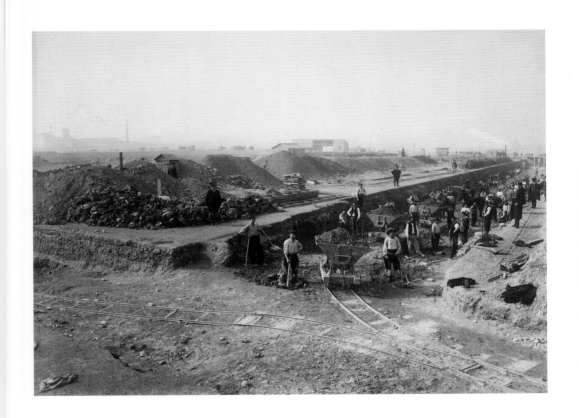

3. Pierre Petit
*Ouvriers et visiteurs posant près
des rails et portant les chariots
de terrassement*
1887

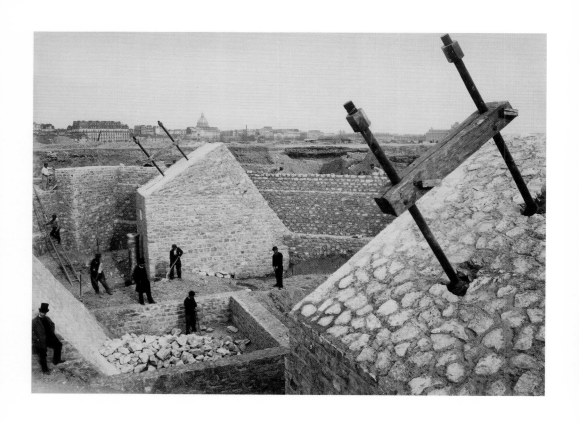

4. Anonyme
Maçonnerie des fondations
Avril 1887

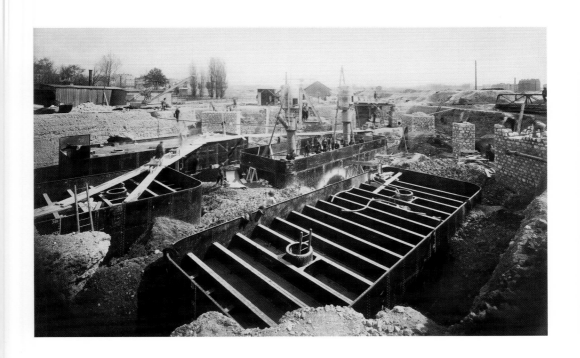

5. Louis-Émile Durandelle
Caissons métalliques
28 avril 1887

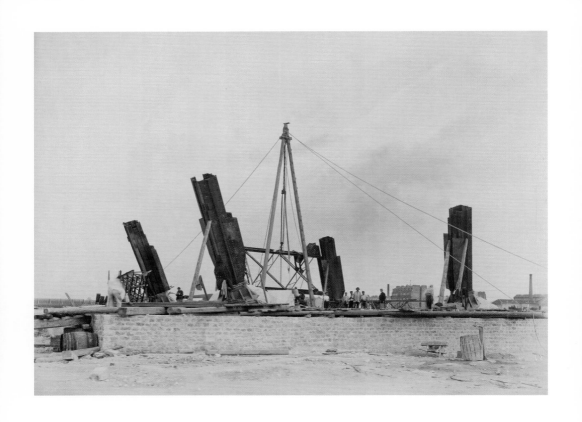

6. Louis-Émile Durandelle
*Les premiers éléments métalliques
d'une pile*
1887

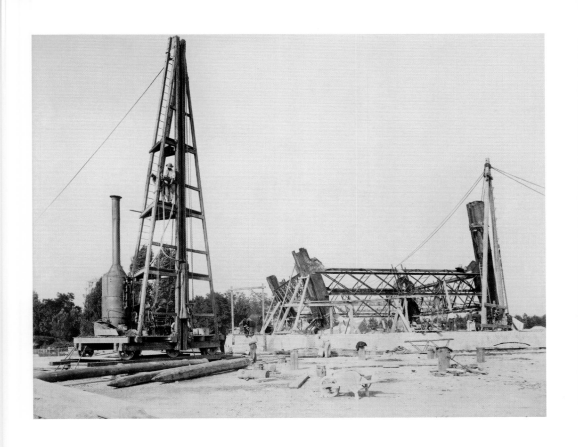

7. Louis-Émile Durandelle
Ouvriers au travail sur un des piliers
de la tour Eiffel
18 juillet 1887

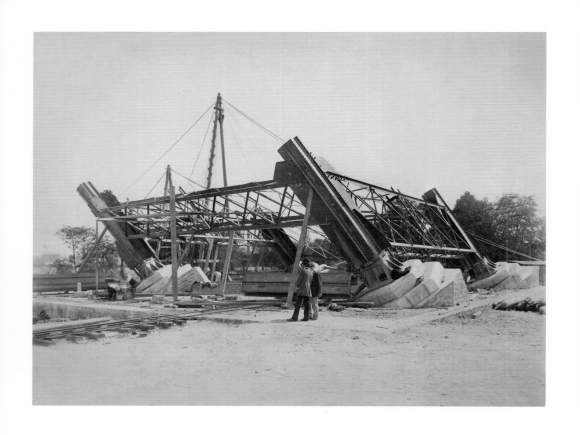

8. Louis-Émile Durandelle
Gustave Eiffel et un autre homme
devant la pile n° 4
18 juillet 1887

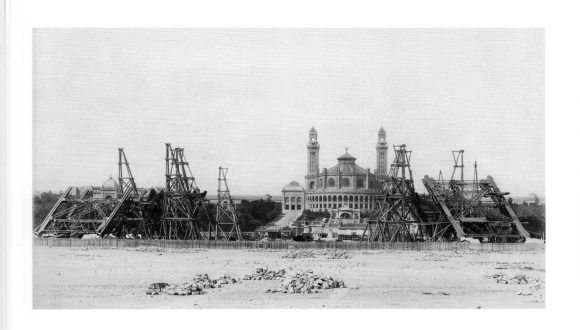

9. Louis-Émile Durandelle
*Les quatre piles, au second plan le
palais du Trocadéro
30 août 1887*

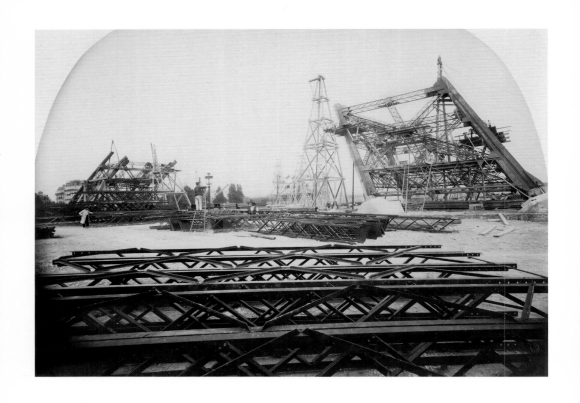

10. Anonyme
*Poutrelles métalliques devant
deux piles en construction*
1887

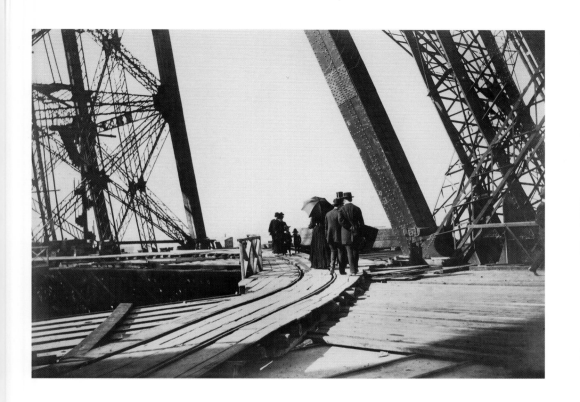

11. Anonyme
Visite à la tour Eiffel en construction
1887

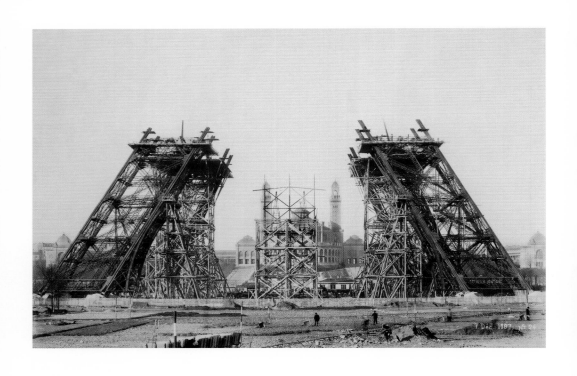

12. Louis-Émile Durandelle
Les piliers de la tour Eiffel
7 décembre 1887

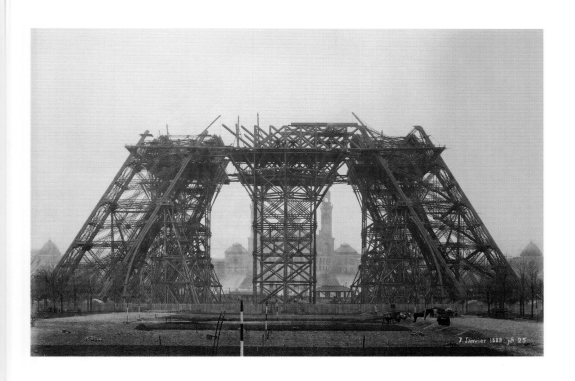

13. Louis-Émile Durandelle
Les quatre piliers de la tour Eiffel et le
commencement de la 1ʳᵉ plate-forme
7 janvier 1888

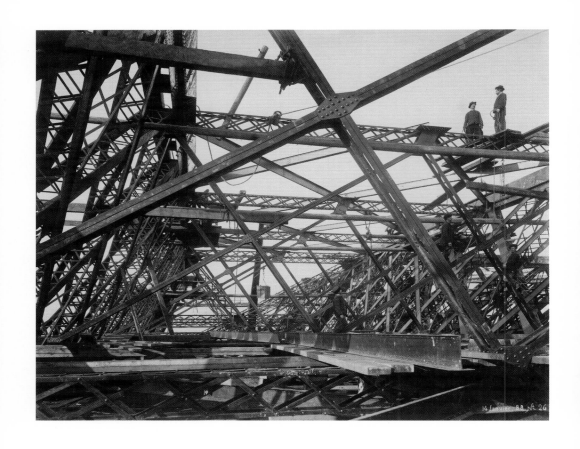

14. Louis-Émile Durandelle
Ouvriers au travail sur les poutres
métalliques
14 janvier 1888

15. Louis-Émile Durandelle
La 1re plate-forme
16 juin 1888

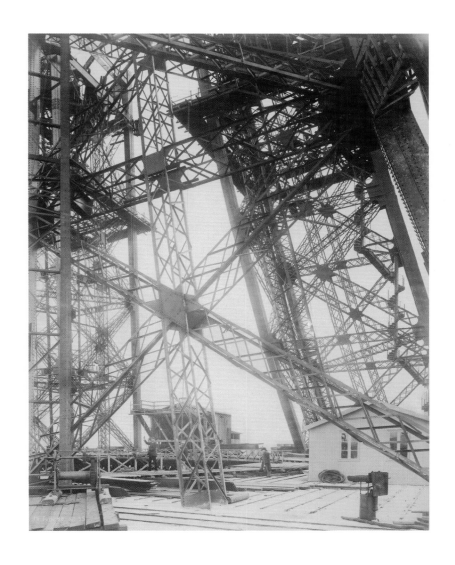

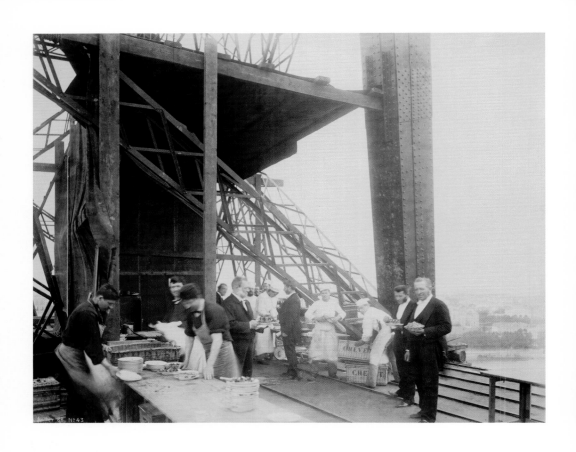

16. Louis-Émile Durandelle
Cuisiniers
4 juillet 1888

17. Louis-Émile Durandelle
La Tour au niveau de la 2e plate-forme, au second plan le palais du Trocadéro 19 juillet 1888

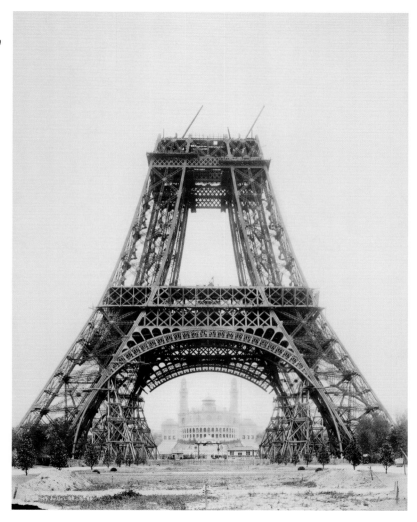

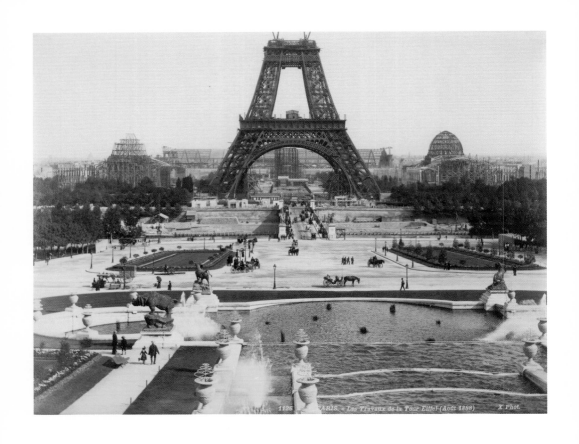

1126 PARIS. – Les Travaux de la Tour Eiffel (Août 1888) X Phot.

18. X Phot, Neurdein frères,
Étienne et Antonin
Les travaux de la tour Eiffel
Août 1888

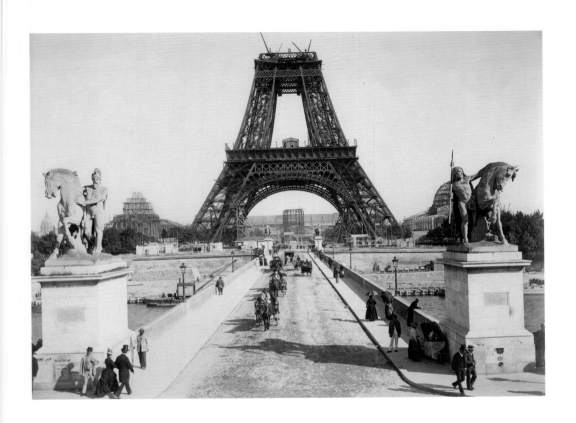

19. Neurdein frères, Étienne et Antonin
La Tour en construction jusqu'à la
2e plate-forme
1888

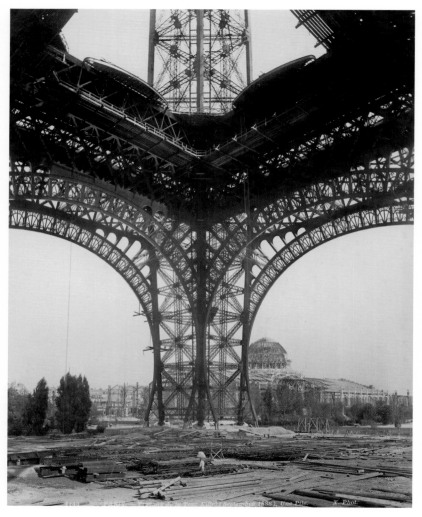

20. X Phot,
Neurdein frères,
Étienne et Antonin
Une pile
Septembre 1888

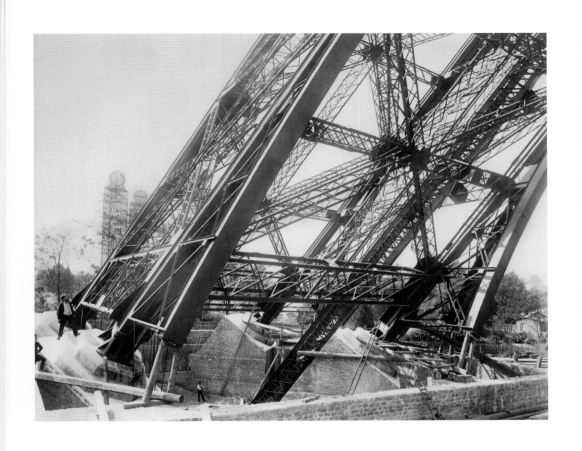

21. X Phot, Neurdein frères,
Étienne et Antonin
Les culées d'une pile
Septembre 1888

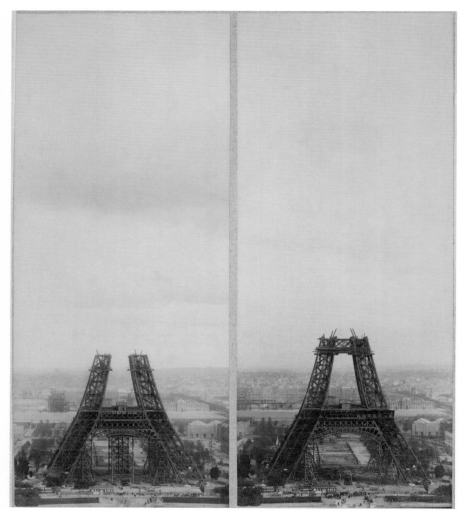

23.

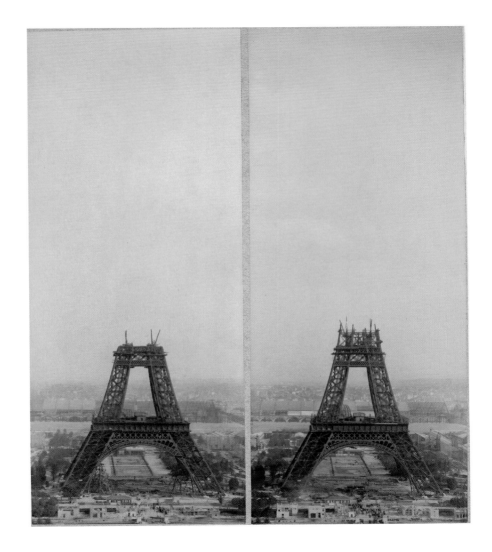

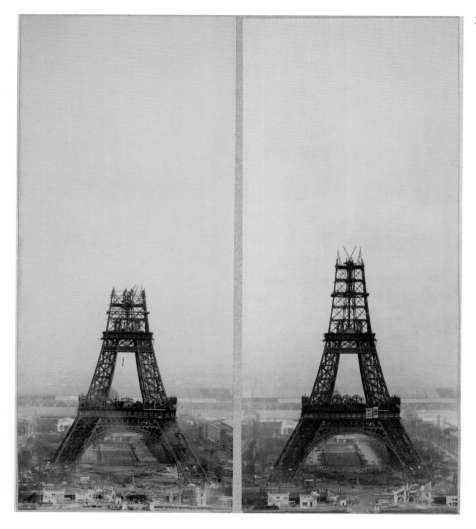

25.

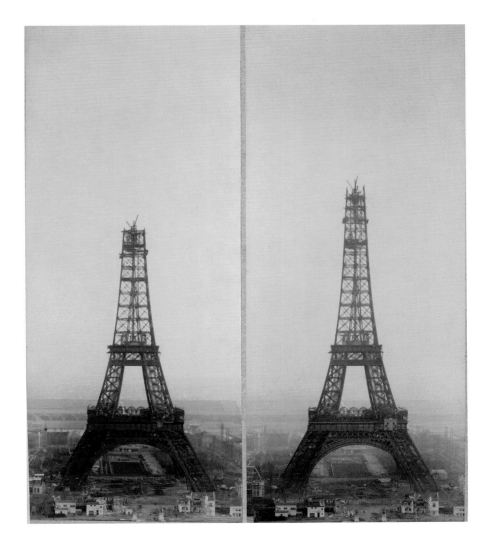

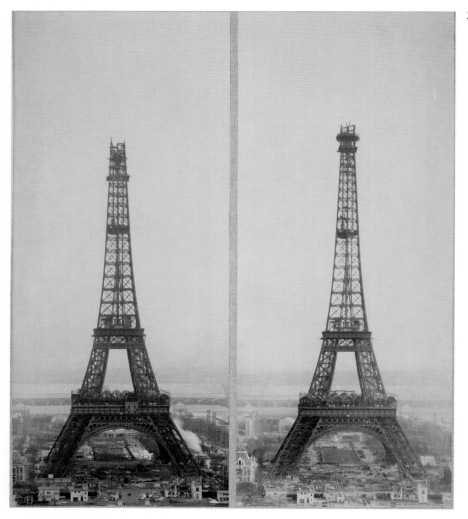

Théophile Féau
La tour Eiffel en
construction :

22. *Juin et*
juillet 1888

23. *14 août et*
14 septembre 1888

24. *14 octobre et*
14 novembre 1888

25. *26 décembre 1888*
et 20 janvier 1889

26. *12 février et*
12 mars 1889

27. *2 avril 1889*

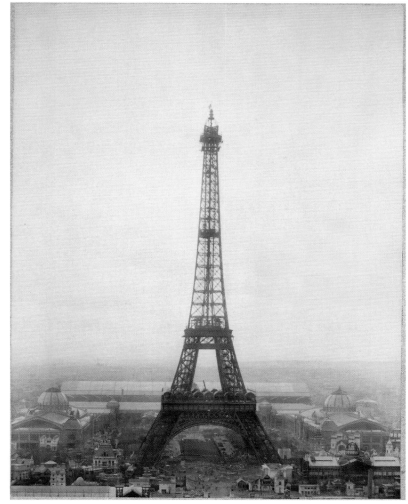

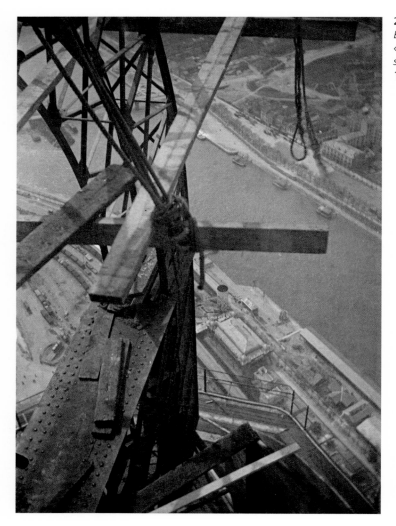

28. Henri Rivière
Échafaudage sur le « Campanile », vue plongeante sur la Seine
1889

29. Henri Rivière
Visiteur sur un
échafaudage du pilier
nord, vue plongeante,
à l'arrière-plan un drapeau,
la Seine et la rive droite
1889

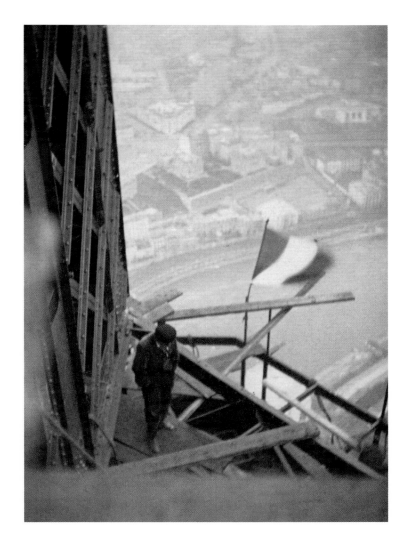

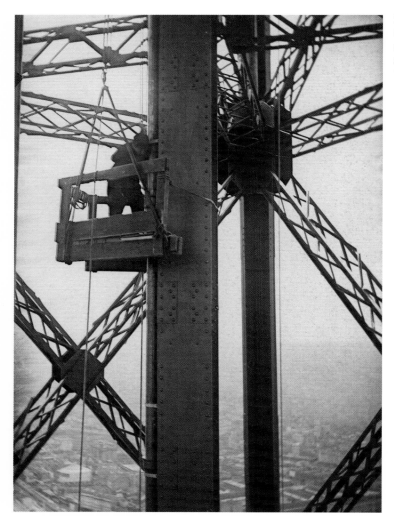

30. Henri Rivière
*Ouvriers sur un
échafaudage travaillant
sur une partie verticale*
1889

31. Henri Rivière
*Un peintre sur une corde
à nœuds le long d'une
poutre verticale, au-dessus
d'un assemblage de poutres*
1889

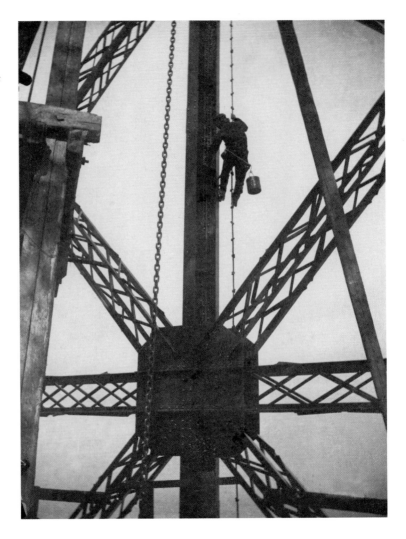

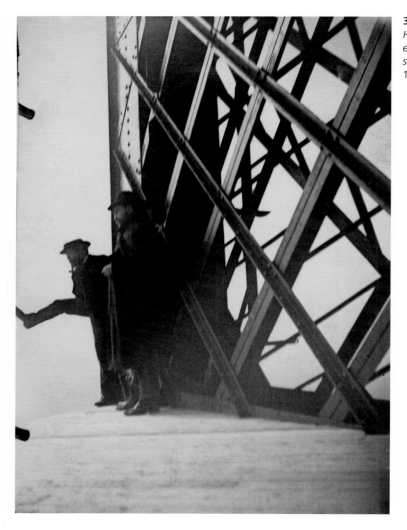

32. Henri Rivière
*Henri Jouard
et Rodolphe Salis,
sur la dernière plate-forme*
1889

33. Henri Rivière
Un ouvrier debout
le long d'une poutre
1889

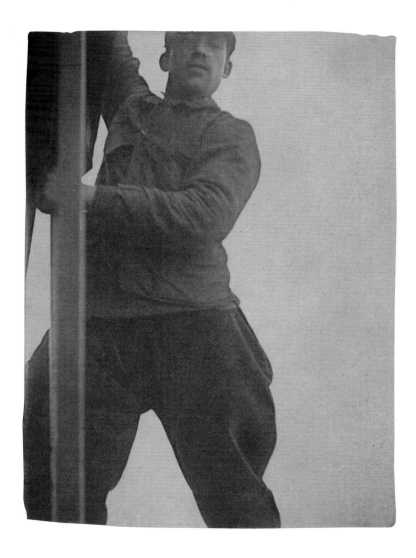

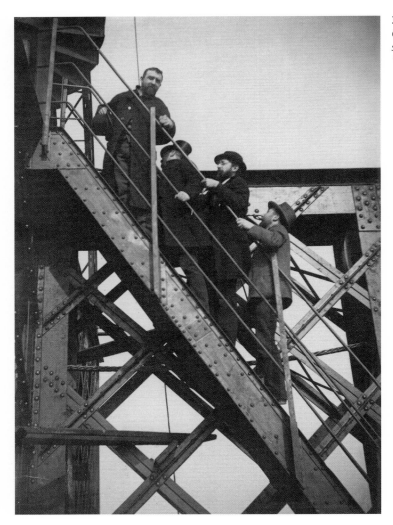

34. Henri Rivière
*Quatre visiteurs
sur un escalier*
1889

35. Henri Rivière
Quatre ouvriers posant sur
un échafaudage au pied du
« Campanile »
1889

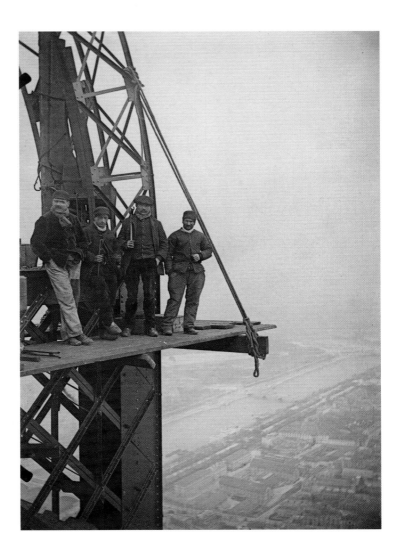

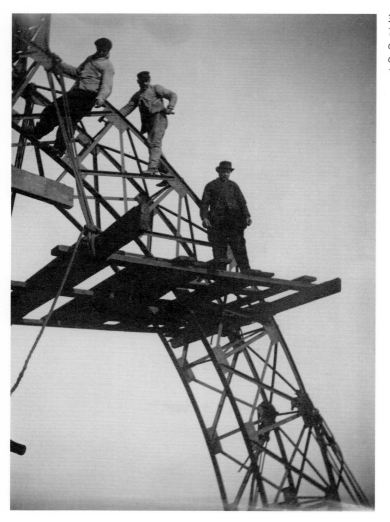

36. Henri Rivière
*Trois ouvriers sur l'échafaudage
d'une poutre en arc
du « Campanile »*
1889

37. Henri Rivière
Le « Campanile »,
la lanterne du phare
et le paratonnerre,
vue en contre-plongée
1889

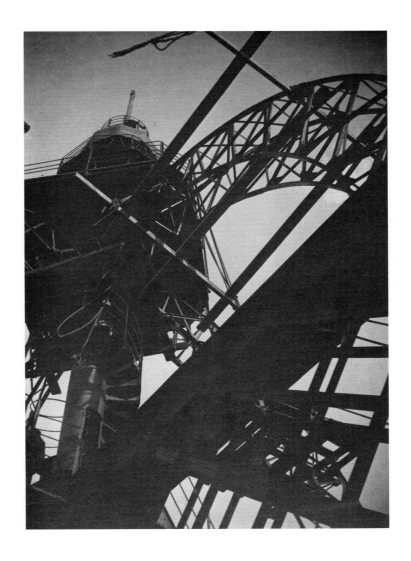

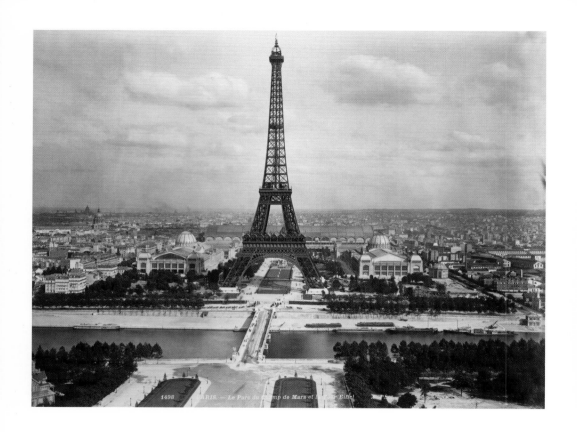

38. X Phot, Neurdein frères,
Étienne et Antonin
*Le parc du Champ-de-Mars
et la tour Eiffel*
1889

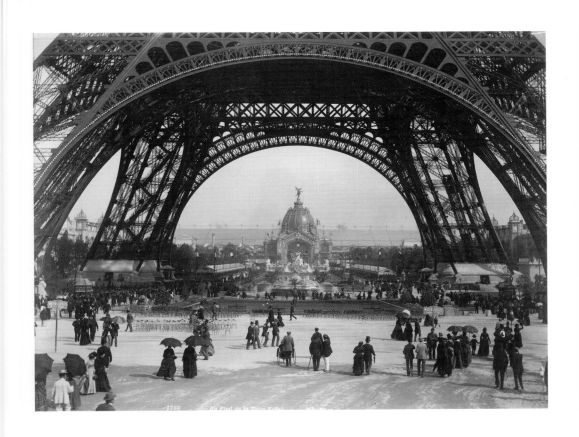

39. ND Phot, Neurdein frères,
Étienne et Antonin
Au pied de la tour Eiffel
1889

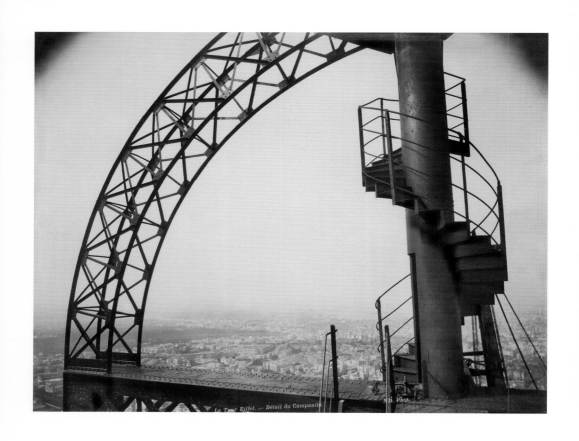

40. ND Phot, Neurdein frères,
Étienne et Antonin
La tour Eiffel, détail du « Campanile »
1889

41. Anonyme,
MM. Eiffel, Salles,
Milon et M^{me} Salles
au sommet de
la tour Eiffel
1889

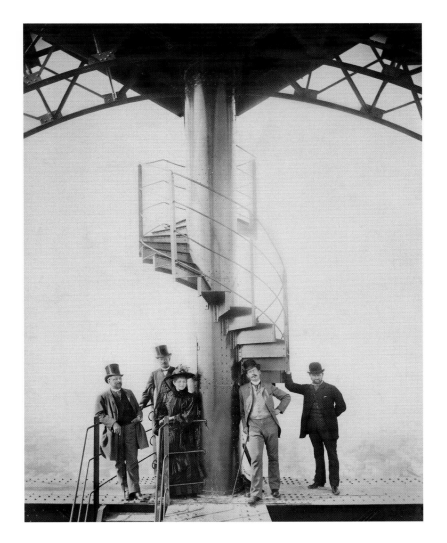

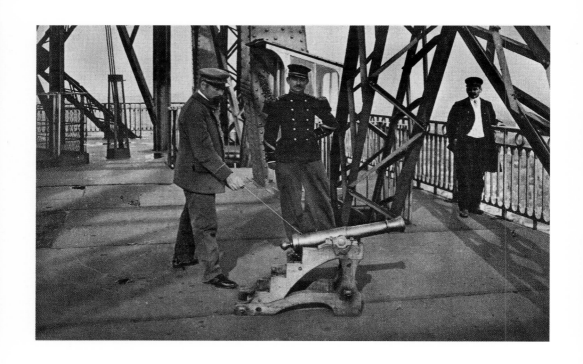

42. ND Phot, Neurdein frères,
Étienne et Antonin
*Le canon de la tour Eiffel au moment
où il va annoncer l'heure de midi*
1900

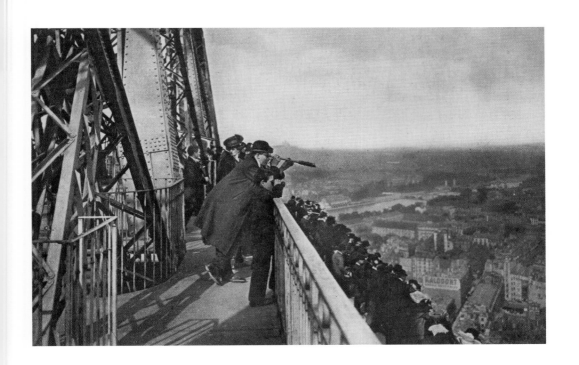

43. ND Phot, Neurdein frères,
Étienne et Antonin
La tour Eiffel, galerie extérieure
du 2ᵉ étage
1900

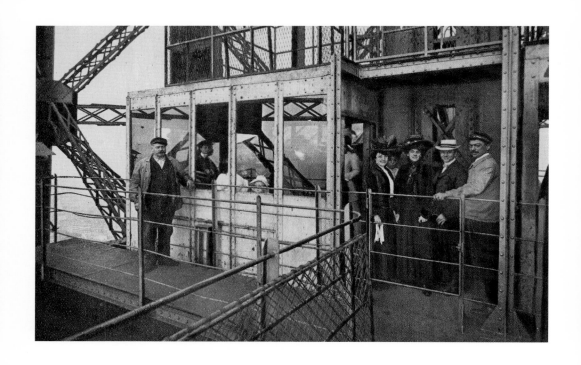

44. ND Phot, Neurdein frères,
Étienne et Antonin
Changement de cabine d'ascenseur
pour les voyageurs qui se rendent du
2ᵉ au 3ᵉ étage – à 200 mètres du sol
1900

45. ND Phot, Neurdein frères,
Étienne et Antonin
Le Sommet de la tour Eiffel
1900

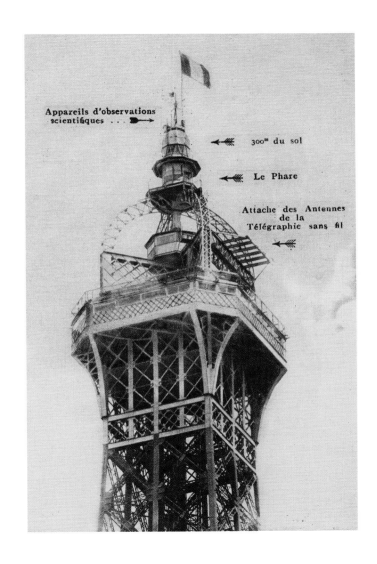

Appareils d'observations
scientifiques . . .

300ᵐ du sol

Le Phare

Attache des Antennes
de la
Télégraphie sans fil

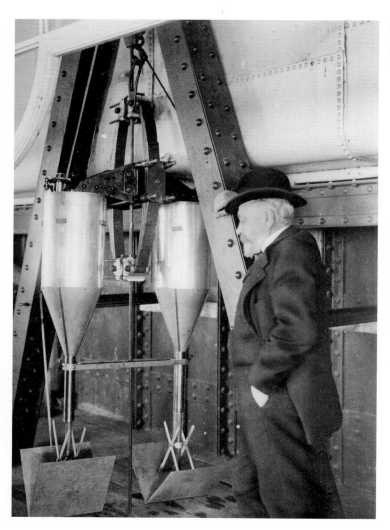

46. Henri Manuel
*Gustave Eiffel et l'appareil
de chute à la tour Eiffel*
1907

47. Henri Manuel
MM. Rith, Eiffel et Milon
devant l'appareil de chute
sous la tour Eiffel
1907

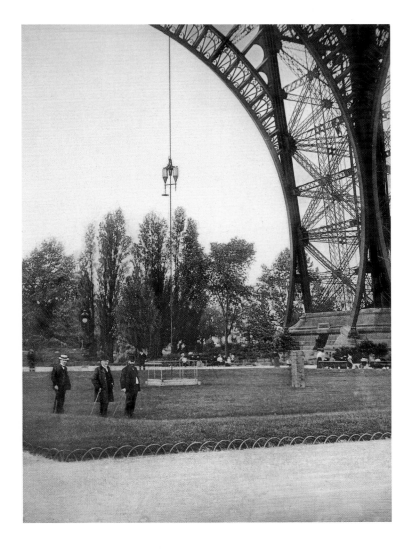

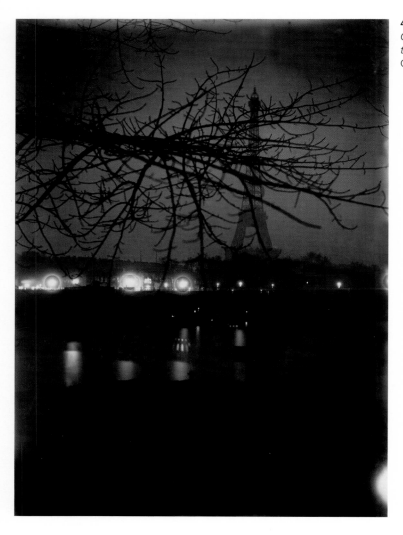

48. Gabriel Loppé
*Quai de la Seine et la
tour Eiffel, dans la nuit*
Ca.1900

49. Gabriel Loppé
*La tour Eiffel et vue
des toits*
Ca.1900

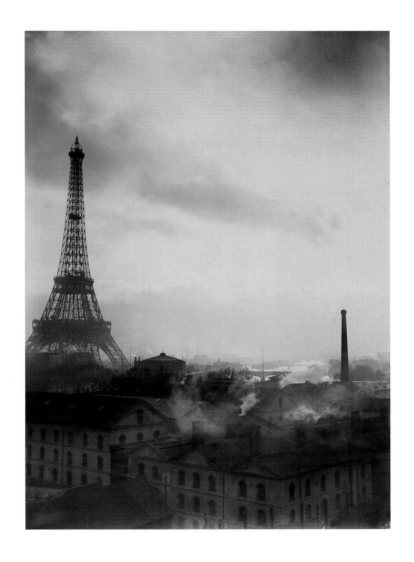

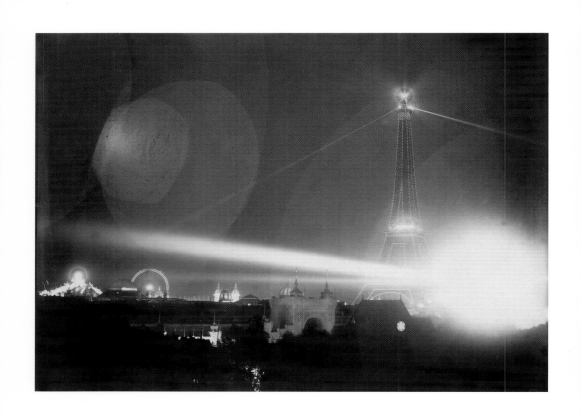

50. Gabriel Loppé
Illuminations de la tour Eiffel
Ca. 1900

51. Gabriel Loppé
La tour Eiffel foudroyée
3 juin 1902

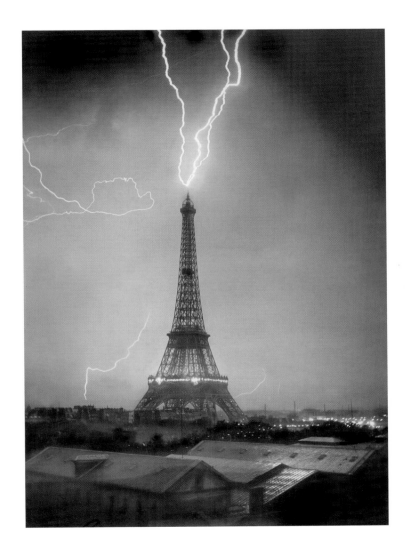

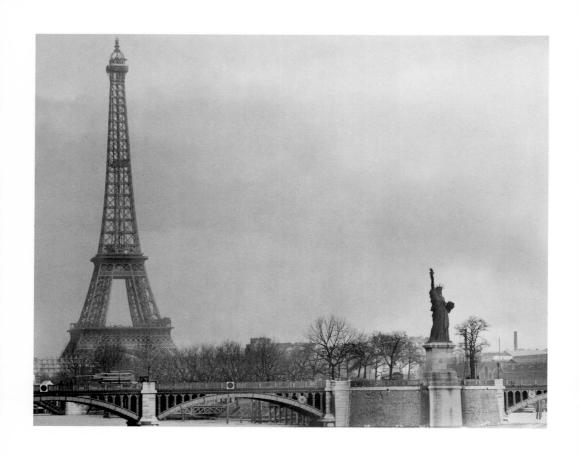

**52. Service photographique
du New York Times**
*La tour Eiffel avec la statue
de la Liberté*

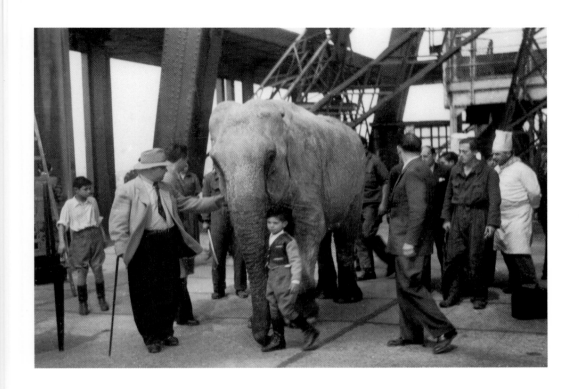

53. Anonyme
Un éléphant du cirque Bouglione
au 1er étage de la tour Eiffel
4 juillet 1948

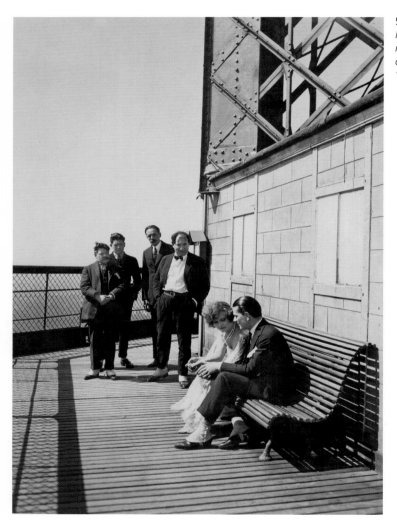

54. René Clair
*Photographie de plateau
réalisée pendant le tournage
du film « Paris qui dort »*
1923

55. René Clair
Photographie de plateau
réalisée pendant le tournage
du film « Paris qui dort »
1923

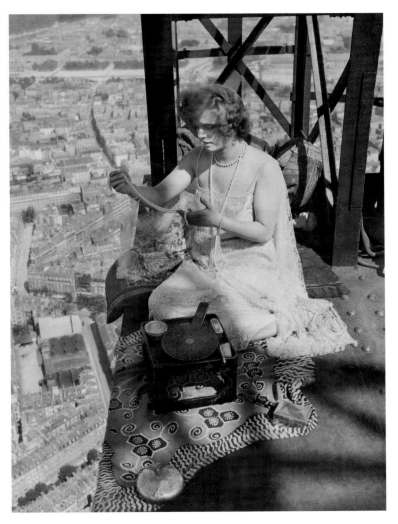

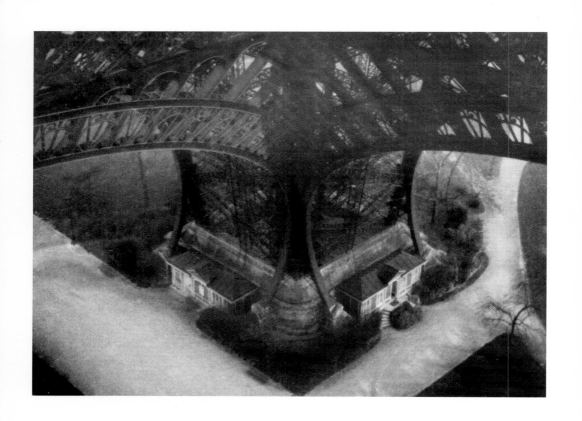

56. René Clair
La tour Eiffel, un pied vu en plongée
1928

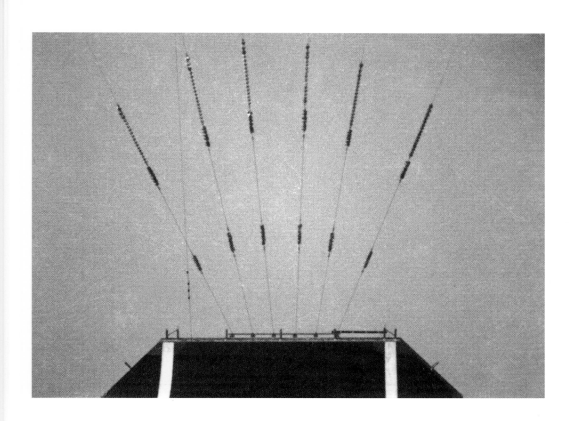

57. René Clair
*La tour Eiffel, antennes de
télégraphie*
1928

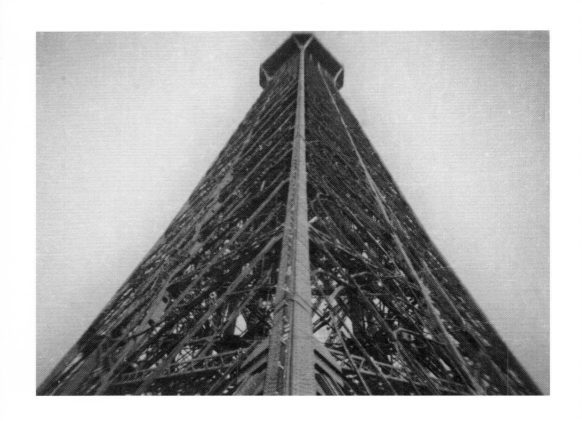

58. René Clair
La tour Eiffel, gros plan sur une arête,
1928

59. Else Thalemann
La tour Eiffel, détail
Ca. 1925

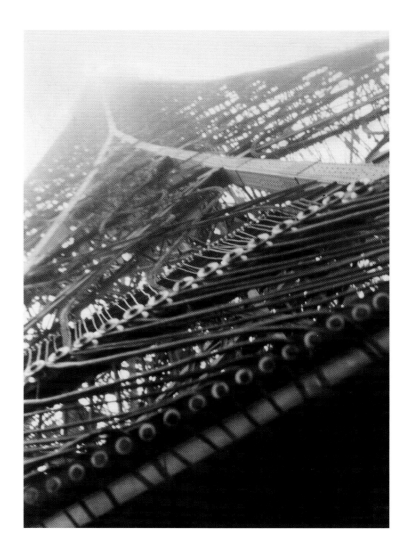

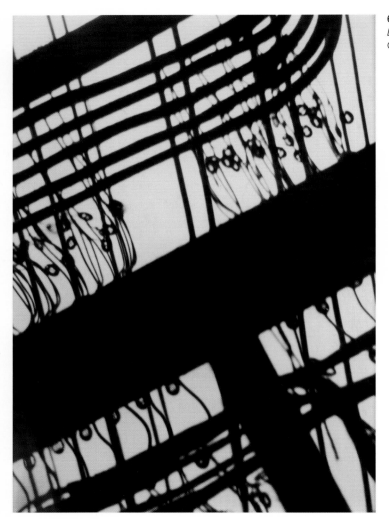

60. Else Thalemann
La tour Eiffel, détail
Ca. 1925

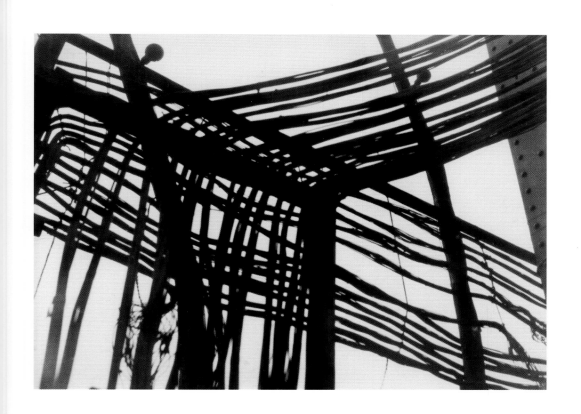

61. Else Thalemann
La tour Eiffel, détail
Ca. 1925

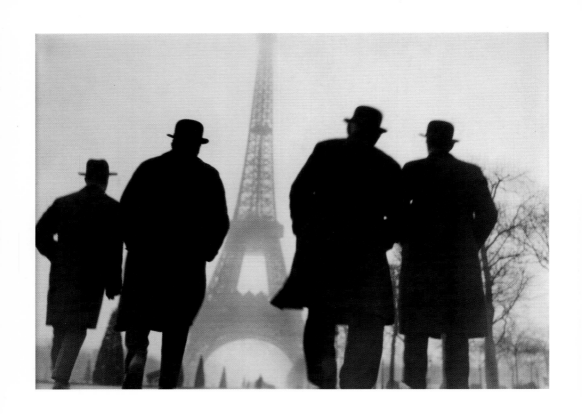

62. Else Thalemann
La tour Eiffel, vue d'ensemble
avec quatre hommes de dos
Ca. 1925